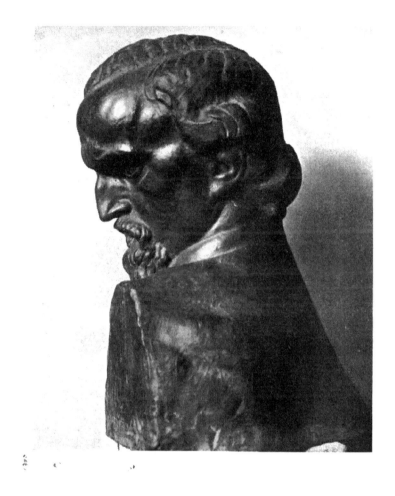

Plate 1 Portrait of the Artist

Exhibition

of

the Works of

Ivan Meštrović

Dr Niko Župančić

London (24.) VI. 1915

Victoria & Albert
Museum
Summer
1915

Honorary Committee:

PRESIDENT—
The Earl Curzon of Kedleston, K.G.

VICE-PRESIDENTS—
His Eminence Cardinal Bourne
His Excellency The Serbian Minister
The Lord Bishop of Oxford
The Right Hon. A. J. Balfour
The Right Hon. D. Lloyd-George
The Right Hon. Joseph A. Pease
The Right Hon. Walter Runciman

MEMBERS—

Auguste Rodin	Emile Verhaeren
C. Aitken	Sir James Guthrie
James Bone	Sir Thomas Jackson, Bart.
Frank Brangwyn	John Lavery
Sir Edward Boyle, Bart.	D. S. MacColl
Sir John Burnet	P. Macgillivray
Noel Buxton	J. W. Mackail
Sir Valentine Chirol	C. Ricketts
Bertram Christian	J. S. Sargent
A. Clutton Brock	R. W. Seton-Watson*
Ernest H. R. Collings*	Solomon J. Solomon
Sir Arthur Evans	H. W. Steed
Nevill Forbes	G. M. Trevelyan
Sir George Frampton	John Tweed
Eric Gill	A. F. Whyte

* From whom information may be obtained at 11 Smith Square, S.W.

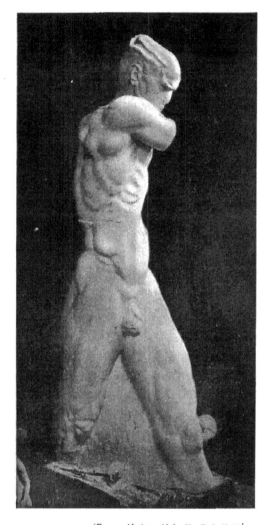

Plate 2 Miloš Obilić

Meštrović and his Art

I VAN MEŠTROVIĆ'S genius was a phenomenon that burst upon Europe at the International Exhibition in Rome in 1911. That Exhibtion was the biggest and most comprehensive assembly of contemporary art that has been brought together, and there the visitor was able to realise how largely European art in these days of rapid interchange of presence and thought had acted and re-acted from one country to another, and how, despite all diversities in mood and achievement, a curious general resemblance, akin to that observable in a family, was becoming apparent throughout the art of civilised nations. The unforgettable exception there was the strange grey building which rose sheer as a fortress or a desert tomb from the grass and flowers and pleasure walks of the exhibition. This was the Serbian Pavilion. Mounting its steep steps you were in a different air and time and aware of a different spirit. You entered a loggia formed of mourning caryatides, down which a sphinx, human save in the wings, stared watchfully and expectantly. Looking between the figures of the loggia, you saw groups of widows whose mourning and hopelessness were expressed in gestures with a primitive directness and force that came as a shock to the visitors. The loggia led to a small domed hall, in which was a gigantic statue of the hero Marko Kraljević, the Serbian Siegfried, on his snorting horse. Round the walls in tall panels were torsos of Turks, and above was a rhythmic frieze of mingled figures of Serbs and Turks fighting. On either side of the hall were arched gateways and inside the arches were grotesque heads of Turks set in panels, two deep all the way round. You descended steps supported by crouching figures that symbolised the Serbs in captivity—gaunt, worn men with beards, their hands, palm downward, extended flat, a sign of subjection and insufferable strain. There was an extraordinary

fury and purpose in every part of this strange building that moved one like the sight of blood or the call of trumpets. It was all described as "fragments of the Temple of Kosovo," the name of the fatal field where the · Serbian nation· went down, to remain in subjection for five hundred years. When in October, 1912, the news came 'that the Serbian army after the battle of Kumanovo had ridden into Skoplje (Uskub), the ancient capital of the race, it seemed like the fulfilment of the prophecy uttered in these statues.

We heard that Ivan Mestrovic the sculptor, who, with the assistance of some Serbian associates and pupils, had designed and modelled the statuary, was still a young man in the early thirties, and that the pavilion, statuary and paintings were all the work of a body of young Serbo-Croat artists gathered from Serbia, Montenegro, Bosnia and Dalmatia, to work together under the flag of Serbia and the leadership of Mestrovic—a national effort inspired by a single fury of national memories and aspirations that is without parallel in modern art. It had a burning spirit within it that seemed to throb and gesture through these forms as a tempest speaks through the new and fantastic shapes it gives to the trees in its grasp, or the announcements of the tongues and crowns of flame in a forest conflagration.

The memories of their common past with its humiliations and sorrows kept alive by the constant incoming of fugitives from the Turkish oppression in Macedonia had made possible their federation and inspired their art. Mourning widows, their mission of life sealed for ever, desperate heroes, advancing Turks moving stealthily, their heads lowered under a guarding arm, their right hand behind them with the ready sword, a strangely sinister apparition ; Turks' heads forming a grinning garland to a doorway ; crouching figures under great weights staring desperately into the future or borne down by their oppression—all these gave an impression that the mind of an imaginative people, moving in half-barbaric turns at a dilated moment of their destiny, was unveiled before us. It was no half-sweet sadness of "old unhappy far-off things and battles long ago," but of a terrible long-suppressed fury with unhappy things at hand and battles to come. One felt such fury boiling up in these twisted knotted figures and swelling national images. Ivan Mestrovic was in his early years a shepherd on his father's mountain farm.

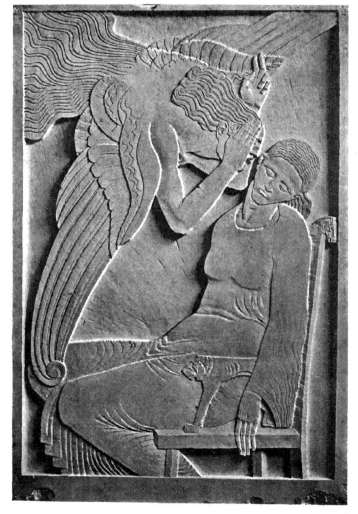

Plate 3 The Annunciation

His inspiration was the noble and vivid folk-song of·his country, and something of the starkness and grandeur and terrible silhouettes of the wild hills·seems to remain in his work. His subject was the death and resurrection of the Serbian race.

In these sculptures Meštrović delivers his testaments; it has the daemonic urgency of archaic art and of the entranced single-ness of the Italian primitives. There is nothing between you and what he has to say; his message is delivered with the immediacy of Fra Angelico. The inspiration he found in the folk song of his country was intensified by the conditions of his life in Dalmatia, almost within hearing of the horrors of Turkish rapine and massacre. Where (until last year in Belgium) but in the Balkans did Europeans know the look on the face of the tortured dead, and how young widows, fugitive from a ravaged land, sat in sorrow ? In all its phrases his art is religious art, its worship of freedom, its expression of the Christian legends are founded on emotional experiences that come from reality. The authenticity of a message in art, however, does not give it permanence any more than good intentions. But Meštrović's message was expressed in terms so germane to his conception that one thinks of his art rather as freeing what he had to say than of clothing it in forms of beauty. Its beauty comes like the beauty of flames, which is fire itself. The sense of man as a god which the ancients had, or of God as a man which Europe had in the days of faith, has almost passed out of our reach and left moderns searching the whole world (even to Tahiti) for new inspirations, or interested only in how near they may get in reproducing the formulas of other ages. Our painters found inspiration in modern costume and gesture, in new coloured harmonies and settings, and in new worlds of vision and light; but sculpture, by sheer unlikeness to the colour and illusion of life, must be intellectual and must speak entirely in its own secret tongue. Meštrović had the fortune to spend his early days in a land throbbing with an unwearied poetry, and touching on every side the primitive realities of suffering and life and death. He began with that great advantage. His early work in Dalmatia was wood-carving, the elements of which he learnt from his father and traces of this technique can still be seen, I think, in his later reliefs with their sheer-cut outline and the character of the decorative shallow

cuttings on the chief surfaces (as, for instance, in the wings of the angel in his "Annunciation"). His art-school training at Vienna seems to have done him no harm, although it was at a period when L'Art Nouveau was raging. His original inspiration lived on while his skill increased, and early in his twenties he seems to have been in full possession of the wonderful craftsmanship that has given freedom to his genius. His conceptions are deeply rooted in the life he knows. In his noble caryatides he has given an eternal formula to the grave enduring Serbian women of the country, his heroes seem memories of the tall Serbian shepherds that loomed over in his youth; his widows are mothers of Serbia. It is perhaps in his purely ideal figure of the mounted legendary hero where he is farthest from what he has known or loved or hated in humanity that Meštrović is least dominant.

In ordinary times the art of Meštrović might be too alien to England with our tradition of decorum and comfort, but in these times of stress the mood has been impelled upon us through which we can see and feel the message of his terrible images and the deep pitifulness, too, that lies within them. His heroic art, indeed, is almost the only art that does not seem alien to these mighty days.

JAMES BONE.

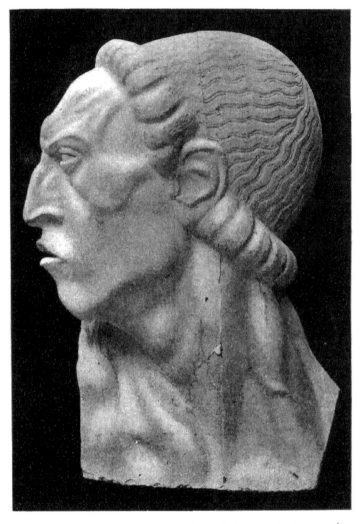

(From a photograph by Mr. E. O. Hoppé)

Plate 4 Serge, the Frowning Hero

Meštrović and the Jugoslav Idea

O F the many tourists who visit the architectural treasures of
Dalmatia and admire the picturesque Slavonic costumes of
its peasantry, the vast majority restrict themselves to three
or four towns along the coast, and make no attempt to explore the
interior. They thus miss a truly remarkable contrast. Leaving behind
us the mellow tones of the little town of Trogir (Träü), the olive groves
and vineyards of the Spalatan riviera, we rapidly mount upwards
into one of the most desolate and forbidding landscapes in all Europe.
From the high ground between Drniš and Šibenik (Sebenico) there is an
almost limitless expanse of stony waste, for all the world as though
the white horses of a breezy spring morning on the neighbouring
Adriatic had suddenly been turned to stone. As far as the eye can
reach, blocks and fragments of stone rise out of the scanty soil and
make vegetation almost impossible. It seems only fitting that such
a land of stone should have produced a great sculptor.

Ivan Meštrović is the son of a Croat peasant family at Otavice,
a hamlet near Drniš, and was born in 1883. He spent his childhood
as a shepherd-boy, and even at this early stage revealed his natural
talent by carving rude decorative figures in wood or stone, as presents
for the peasants of the neighbourhood; some of these early efforts
are religiously preserved in the museum of Knin. He grew up under
the impression of Serbo-Croat popular poetry, which has survived in
a purer form in the highlands of Dalmatia than perhaps in any other
portion of Southern Slav territory. Until he was approaching manhood,
these ballads were practically his only reading; and many others

still exist by oral tradition. The ancient Slavonic liturgy which has been sung for over 1,000 years in some of the churches along the coast, has not been without its effect upon the language, and some critics have attempted to trace the " far-away " archaic flavour which is so noticeable in his work to this continuity of Slavonic tradition in his Dalmatian house. Growing up in a district which contains the ruined sites of the castles of the early Croatian kings, and even to-day preserves the traditions of the notorious Uskok pirates and the Haiduk (robber) chiefs who so long infested the old Turkish border— Mestrović was from the first under the influence of keen national feeling ; and it was thus natural that his first serious attempts at sculpture should have been the heads of modern Croat patriots.

At the age of eighteen he was apprenticed to a marble worker at Split (Spalato), and later, with a bursary from the Town Council, went to the Academy of Arts at Vienna, where he made rapid progress in technique. In his second year of study (1902) he already exhibited in the Sezession, and since then almost annually at that society's exhibitions. In 1907 he went to Paris and exhibited in the Salon d'Automne of that and the two following years. His first collective exhibition was held in 1910 at the Sezession of Vienna, where it aroused great interest. He made his first appearance before his own countrymen the same summer at Zagreb (Agram), the Croatian capital, conjointly with the Croat painter Racki. In 1911 the Zagreb exhibits, with certain notable additions, were transferred to Rome, where they formed the chief feature of the Serbian Pavilion in the Exhibition of International Art.

The figures of Marko Kraljević and other heroes of Serbian legend, and the first architectural designs for a kind of Southern Slav Pantheon, to be erected on the battlefield of Kosovo, created a real sensation in the artistic world. In 1912 the completed wooden model for the Temple of Kosovo, which has now come to London, was exhibited for the first time at Belgrade, and was widely accepted as a true expression of Serbian national tradition. He has also exhibited more than once in Venice and Munich; but this is the first occasion on which his art has been at all fully represented on this side of the Channel.

The short period of Mestrović's artistic activity coincides with a period of unexampled development and unrest in the political life of

his nation, and it is essential to point out that the chief impetus to the growing movement in favour of Serbo-Croat Unity came from his own province of Dalmatia. Alike in politics, in literature and in art, the moving spirits of the past ten years have been Dalmatian Croats, and the student movement which has played so great a part in Southern Slav history was at least as strong among the Croats of Dalmatia as among the Serbs of Bosnia. At the very moment when misrule in Croatia was at its height, the dramatic events of the Balkan War electrified the Southern Slav world. After five centuries the great defeat of Kosovo was avenged and the Turks were finally expelled from Serbian soil. The achievements of the Balkan Allies carried the Serbo-Croat population of Bosnia, Dalmatia and Croatia completely off their feet in a wave of enthusiasm. In the words of one of their own leaders, they had regained their belief in the future of their race. " In the Balkan sun," exclaimed another on a public platform, "we see the dawn of our day."

Some knowledge of these facts is essential to a true understanding of Meštrović; for the man and his work are thoroughly imbued with the spirit which animates the younger generation of Jugoslavs. Indeed he combines to a remarkable degree an intimate sympathy with historic tradition and primitive feeling, and the keenest possible interest in the present day fortunes of his race. To him there is only one reality to-day, and that is the national ideal of unity. He was first stirred by the Bosnian crisis of 1908-9 into open sympathy with Serbia, and conceived the idea of interpreting in stone the mythology and popular poetry of the Serbs. Any such attempt must naturally be focussed upon the famous battle of Kosovo (1389), in which the mediæval Serb Empire fell before the onslaughts of the Turks, and the last Serbian Tsar perished in the fray. The romantic story of the battle and its heroes forms the subject of a whole series of popular ballads, which throughout the era of Turkish domination, and no less so at the present day, are a living reality among the Serb and Croat peasantry on both sides of the Austro-Serb frontier. The red cap with its black band, which has so long been the national head-dress of the Montenegrin and Dalmatian peasantry, is said to have been originally adopted as a sign of grief for Kosovo, and for five centuries the anniversary of the

battle, the 28th of June—St. Vitus's Day ("Vidov-Dan") was a day of national mourning, until it was gloriously avenged on the fields of Kumanovo and Monastir by the armies of Peter Karageorgević.

These splendid ballads, unequalled for directness and imagination, save perhaps by the ballads of the Anglo-Scottish Border, have been chanted at every fair and festival by the gusla-players, who celebrate the prowess of Miloš and Marko, of Zrinsky and Frankopan, and of many a famous "haiduk" chief.

Nor should one all-important factor be left unmentioned. The priests of the Serb Orthodox Church bravely kept the national flame burning in the long night of Turkish oppression, and equal credit is due to the Catholic clergy among the Croats, who have always been the true leaders of national aspiration—from the Franciscan friar Kačić, who in the eighteenth century revived the tradition of popular poetry in Bosnia and Dalmatia, to the great Croat patriot Bishop Strossmayer whose centenary celebration has been submerged by the tragedy of a world-war.

In a word the works of Ivan Meštrović form an apotheosis of the Jugoslav idea, and are accepted by his compatriots as symbolic of their national dream. Their native force and virility reveal to us the secret of the Serbian revival, and help us to understand the unconquerable spirit which has thrice repelled Austria's "punitive expeditions," and so nobly vindicated Serbia's place in the ranks of the Allies.

<div align="right">R. W. SETON-WATSON.</div>

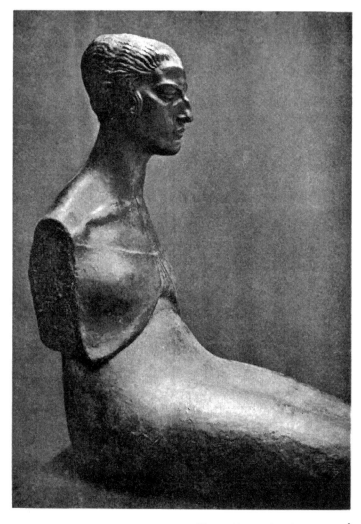

(From a photograph by Mr. E. O. Hoppé)

Plate 5 Portrait of a Lady

CENTRAL HALL

1. THE TEMPLE OF KOSOVO *Wooden Model*

The great battle fought on 28th June, 1389, on the plain of Kosovo—the fatal "Field of the Blackbirds"—is the most memorable of landmark in Balkan history. It decided the fate of the ancient Serbian Empire and ushered in the period of Turkish domination, which was to last over four centuries. Few battles in history have been so rich in romantic episodes—the treachery of Vuk Branković, the slaying of the Sultan Murad, by Miloš Obilić, the death of Tsar Lazar, the lament of the Serb mother over her nine sons—and an inexhaustible crop of legends and ballads dealing with the tragedy has arisen throughout the Southern Slav world. To this day the ballads of Kosovo arouse the same echo wherever the Serbo-Croat language is spoken—in Serbia and Montenegro, in Bosnia and Dalmatia, in Croatia and Southern Hungary; and many of them have acquired an allegorical and almost mystical meaning.

The true tragedy of Kosovo lies in the destruction wrought upon a young and vigorous culture which was struggling into existence and was keenly conscious of its spiritual kinship with Western Europe. It was at one and the same time a blow dealt at Christendom and at the Slav idea, and it has taken five and a-half centuries finally to avenge the blow. To-day we are witnessing in the movement for Jugoslav Unity the realization of long submerged ideals. Of these ideals Meštrović may fairly be regarded as the prophet and the keystone. To him Kosovo is a historic watchword, the expression of a nation's soul; and hence the battlefield of Kosovo—that Balkan Flodden, in whose common disaster every Christian people of the Peninsula shared, and which in its expiation seems an omen of future harmony and union—is the only possible site for the Southern Slav Valhalla, which he has conceived as the artistic interpretation not merely of Serb national and religious aspirations, but of the wider teachings of humanity.

2-13. THE CARYATIDS *Plaster*

Twelve types of Serbian womanhood during the long era of Turkish oppression. The load is upon them, but cannot break

them; and in due time they have become the mothers of new heroes. They are the link between Marko and Miloš, the fabulous heroes of old time, and the heroes of Serbia's resurrection under Kara George and in the new epic of the twentieth century. They are also conceived as allegorical figures, representing the various Southern Slav lands—the redeemed, Serbia, Montenegro and "Old Serbia," and the "unredeemed," Bosnia-Herzegovina, Dalmatia, Croatia-Slavonia, Istria and Slovenia, and the Voivodina

These figures stand in the Atrium leading towards the central hall of the Temple of Kosovo.

14-19. THE WIDOWS OF KOSOVO
Two groups in marble, and four plaster figures

The figures of these widows are symbolic of the Womanhood of the Serbian race, mourning the fatal issue of the battle and the destruction of the Serbian Empire. "The flowers o' the forest are a' wede awa'."

20. THE GREAT SPHINX *Plaster*

This figure was originally intended as the sepulchral monument of Silvije Kranjčević, one of the most original of Croat poets. Later, the artist decided to place it, remodelled on a huge scale, in the sanctuary of the Temple of Kosovo, as a symbolic figure of the destinies of the Southern Slav race.

21. MILOŠ OBILIĆ. Colossal Torso *Plaster*

Miloš Obilić was the Serbian knight who on the eve of the fatal battle of Kosovo, found his way into the Turkish camp and slew Sultan Murad with his own hand. He is described in many ballads as "the most noble and vehement of heroes," and has been treated by Meštrović as the central figure of the Kosovo cycle.

22. COLOSSAL HEAD OF MILOŠ *Plaster*

As designed for the colossal statue which is to be placed in the central hall of the Temple of Kosovo.

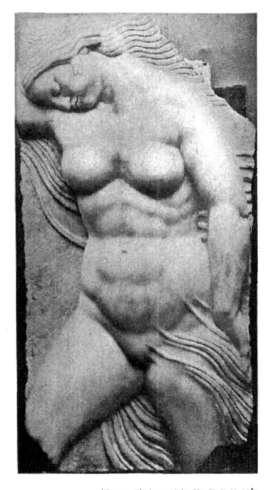

(From a photograph by Mr. E. O. Hoppé)

Plate 6 The Dancing Woman

WEST HALL

The Heroes

23. "SRGJA ZLOPOGLEDJA"— SERGE, THE FROWNING HERO *Plaster*

In a famous Serb ballad we read of—
" This angry hero of the frown
" Who spits six Turks upon his lance
" And flings them backward o'er his head
" Across the river Sitnica,
" Six at a stroke and six again."

24. MARKO KRALJEVIĆ. Study of a Head *Plaster*

Marko Kraljević (Mark the King's son) is the most famous figure in Serbian legend and popular poetry. In the period of decay which followed Kosovo, he ruled a small semi-independent state in northern Macedonia, and was a noted champion of the Serb peasantry against the Turkish invader. With his mythical grey charger Sarac, he was the hero of a hundred marvellous adventures. His figure has fired the imagination of the race, and to every Southern Slav—Slovene and Bulgar no less than Serb and Croat—Marko looms as large as Roland to the Frank or Siegfried to the Teuton. He personifies to a peculiar degree the national spirit of the Serb.

25. MARKO KRALJEVIĆ *Plaster*
Study for Colossal Equestrian Statue

Marko is attacking single-handed a band of 300 Turks, with the cry " Brothers, to-day I will avenge you or perish." As an an illustration of the place which Marko occupies in the mind of the people it is worth noting that in the first Balkan War (1912) many Serbian soldiers claimed to have seen Marko on his grey charger waving them on to victory. Nothing could shake them in this belief.

26. TORSO OF A HERO *Marble*

The "glorious" hero Strahinić Ban, renowned for his manly beauty.

27. THE VICTOR - *Plaster*

This figure is a sketch for a colossal figure (about 25 feet in height), to be erected on a column of victory in Belgrade, in commemoration of the final expulsion of the Turks from Serbian soil.

28. A CARYATID *Wood*

29. THE SLAVE *Plaster study*

30. PORTRAIT OF LEONARDO BISTOLFI *Bronze*
The famous Italian sculptor

31. PORTRAIT OF THE ARTIST'S WIFE *Marble*

32. PORTRAIT OF A LADY *Bronze*

33. FEMALE HEAD *Marble*

34. FEMALE HEAD *Black marble*

35. PORTRAIT OF MADAME BANAZ *Marble*
(Lent by Mr. Natale Banaz)

36. HEROIC HEAD (Lent by Mr. John Lavery) *Bronze*

37. PORTRAIT OF THE ARTIST'S MOTHER *Plaster*

38. PORTRAIT OF AUGUSTE RODIN ,,

39. CHRIST ON THE CROSS ,,

40. CHRIST AND THE WOMAN OF SAMARIA
 Plaster relief

41. THE ANNUNCIATION ,, ,,

42. VIRGIN AND CHILD WITH ST. JOHN ,, ,,

These three reliefs are not castes but have been carved directly on the plaster.

43. PIETÀ *Bronze relief*

44. THE DEPOSITION FROM THE CROSS *Wood relief*

45-46. TWO DECORATIVE RELIEFS *Wood*
For the porch of a Chapel

47. SALOME *Bronze relief*

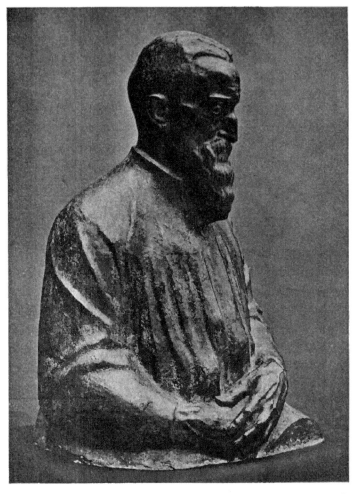

(From a photograph by Mr. E. O. Hoppé)

Plate 7 Portrait of Leonardo Bistolfi

48. THE DANCING WOMAN *Marble Torso*
49. THE DANCING WOMAN " "
50. THE LITTLE SPHINX *Plaster study for the same*
51. PORTRAIT OF A WOMAN *Bronze*
52. PORTRAIT OF A GIRL "
53. PORTRAIT OF A MAN "
54. PORTRAIT OF A MAN "
55. HEAD OF THE VICTOR (see No. 27) "
56. PORTRAIT OF MEDULIĆ (Andrea Schiavone) *Plaster*

Medulic, better known under his Italian name, was a native of
Dalmatia and, as the name denotes, was of Slav nationality.

57. THE BLIND GUSLA-PLAYER *Plaster*

The gusla is the primitive national instrument of the Serb—a kind
of one-stringed violin, used to accompany the recitative of the
national ballads. The gusla-players correspond to the ancient
Celtic bards; many of them were blind and possessed the gift of
second sight.

58. A DALMATIAN PEASANT *Plaster head*
59. A YOUNG DALMATIAN PEASANT " "
60. A DALMATIAN PEASANT GIRL " "
 The artist's sister
61. VASE *Plaster*
62. VASE "
63. VASE (Lent by Mr. Natale Banaz) *Bronze*
64. STUDY OF A WIDOW AND CHILD "
65. STUDY OF A CROUCHING WOMAN "
66. STUDY OF A CROUCHING WOMAN "
67. STUDY OF A HAND "
68. VIRGIN AND CHILD *Plaster*
69. FIGURE OF A WOMAN "
70. FIGURE OF A WOMAN "
71. FIGURE OF A WOMAN "

72. SERBIA'S WAR OF LIBERATION *Bronze*

Design for medal in honour of the victors in the first Balkan War
(1912-1913). Inscription: "Peter. I. the Liberator;" (reverse)
"Kosovo avenged, 1912-1913."

73. COLOSSAL WINGED FIGURE *Bronze*

Specially designed to stand on a Pylon in front of the Serbian
Pavilion at the Roman Exhibition of International Art (1911).
The figure holds on its hand a torso of the hero Miloš Obilić.

74. WINGED FIGURE (Sketch for the above) *Bronze*

□ □ □

For reference to Meštrović and his work, see *Burlington Magazine*
and *Colour* for March, 1915; *Near East*, May 21st, 1915; *Queen*, May,
1915; *Emporium* (Bergamo), May, 1910; *L'Eroica* (special Serbian
number), Spezia, 1914; *L'Arte Mondiale a Roma, 1911*, by V. Pica,
Bergamo, 1913; *Die Kunst für Alle*, November, 1911; *Deutsche Kunst*,
June, 1910; Catalogues (1) Meštrović-Rački Exhibition, Zagreb (Agram)
1911; (2) Rome International Exhibition, Rome, 1911; (3) Venice, 1914.

□ □ □

The following is a brief list of books in English dealing with Serbia and the
Southern Slavs: Servia of the Servians, by Čedo Mijatović, 1911; Servia,
the Poor Man's Paradise, by Herbert Vivian, 1897; Hero Tales and Legends
of the Serbians, by V. M. Petrovic, 1914; Servian Popular Poetry, by Sir
John Bowring, 1827; Serbske Pesme, by "Owen Meredith" (Lord Lytton),
1861; Kossovo (a translation of the cycle of ballads), by Elodie Lawson
Mijatović, 1881; The Slav Nations, by Srgjan Tucić, 1915 (Daily Telegraph
war Books); Dalmatia, by Sir Thomas G Jackson, Bart, 3 vols 1887, The
Southern Slav Question, by R. W. Seton-Watson, 1911, and the same
author's The Spirit of the Serb in "(in "The Spirit of the Allied Nations,"
Ed. Sidney Low, 1915).

□ □ □

Serbo-Croat Orthography:

š=sh *in ship;* č=ch *in church:* ć, *the same (less hard);*
ž=j *in French jour;* c=ts *in cats;* j=y *in you.*

□ □ □

Photographs of the statuary may be obtained from Mr. E. O. Hoppé,
7 Cromwell Place, S.W. (or at the Museum).

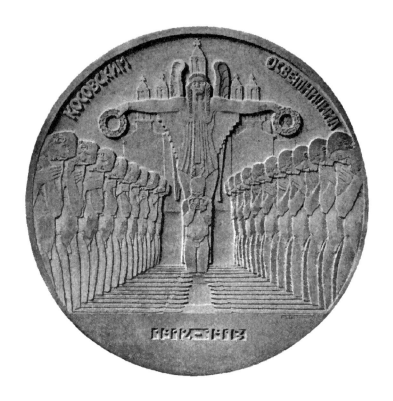

Plate 8 Kosovo Avenged

Milton Keynes UK
Ingram Content Group UK Ltd.
UKHW022029151223
434483UK00005B/184